FOR BRAD AND JOHN, OUR BETTER HALVES.

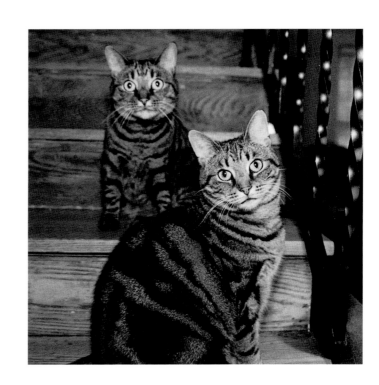

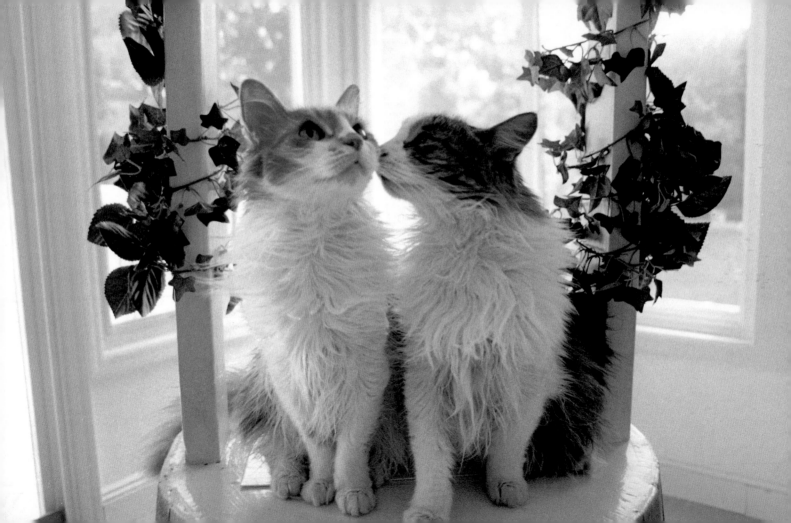

catRIMONY

THE FELINE GUIDE TO RULING THE RELATIONSHIP

Photographs by KIM LEVIN

Written by CHRISTINE MONTAQUILA

STEWART, TABORI & CHANG • NEW YORK

Project Manager: Marisa Bulzone
Editor: Dervla Kelly
Designer: Susi Oberhelman
Production Managers: Kim Tyner and Devon Zahn

ISBN 10: 1-58479-550-6
ISBN 13: 978-1-58479-550-6

Published in 2006 by Stewart, Tabori & Chang
An imprint of Harry N. Abrams, Inc.

The text of this book was composed in Futura and Berthold Bodoni.

Printed and bound in China by Midas Printing Ltd.

10 9 8 7 6 5 4 3 2 1

HNA ▪▪▪▪▪
harry n. abrams, inc.
a subsidiary of La Martinière Groupe

115 West 18th Street
New York, NY 10011
www.hnabooks.com

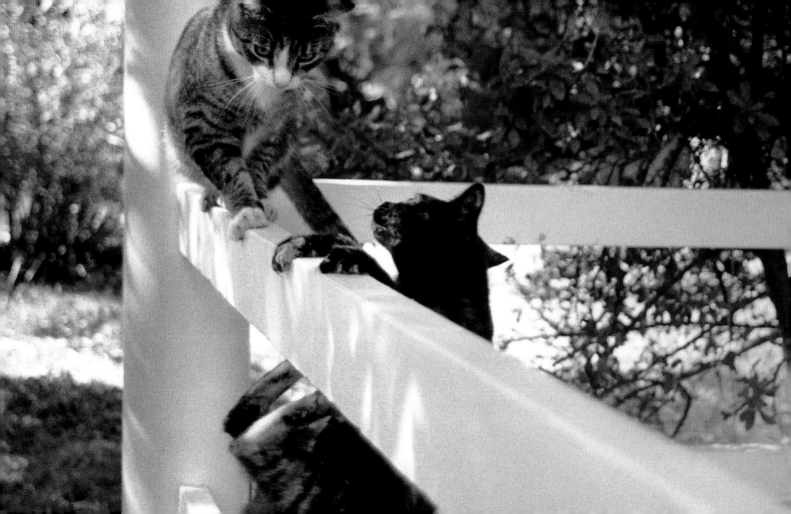

Find someone with the same **babe-quotient**.

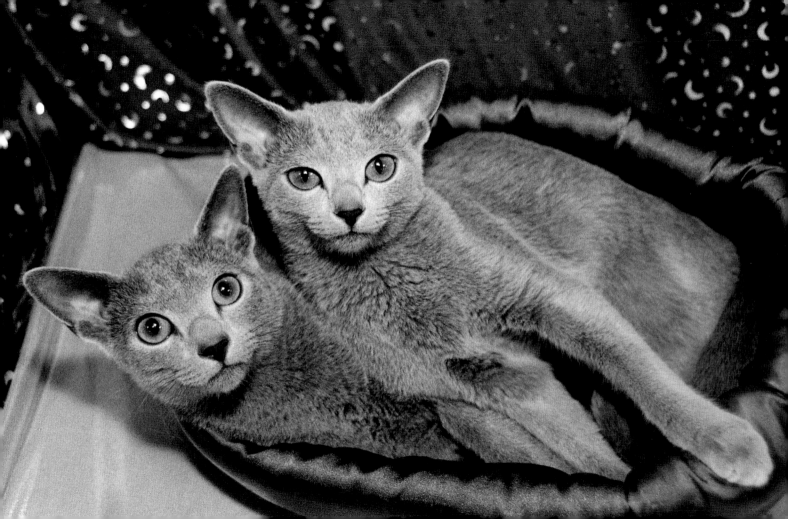

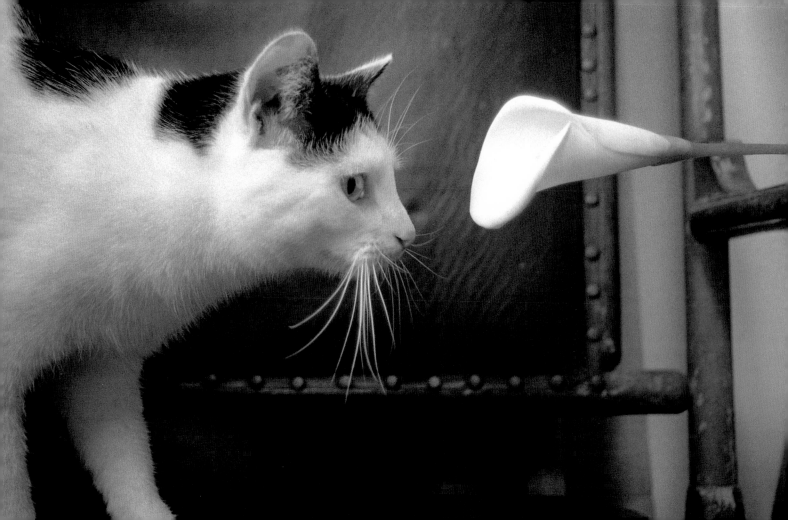

Insist all apologies be long-stemmed.

OREO

Stage a **wardrobe intervention.**

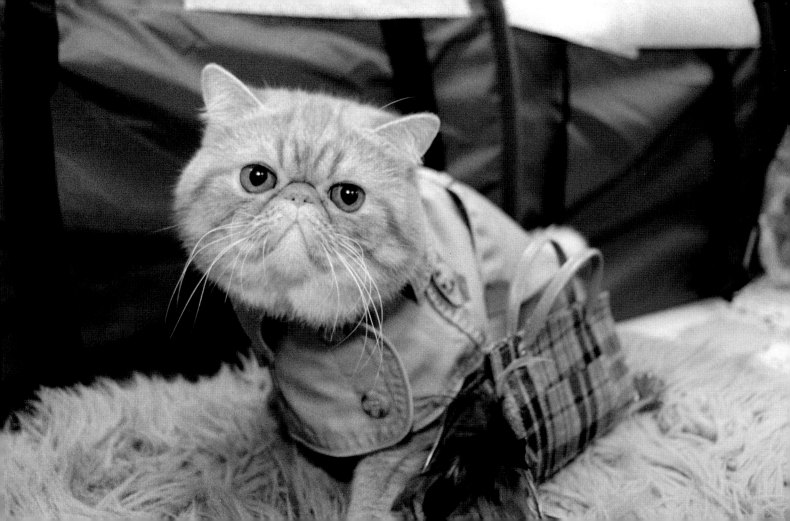

Think out of the missionary position.

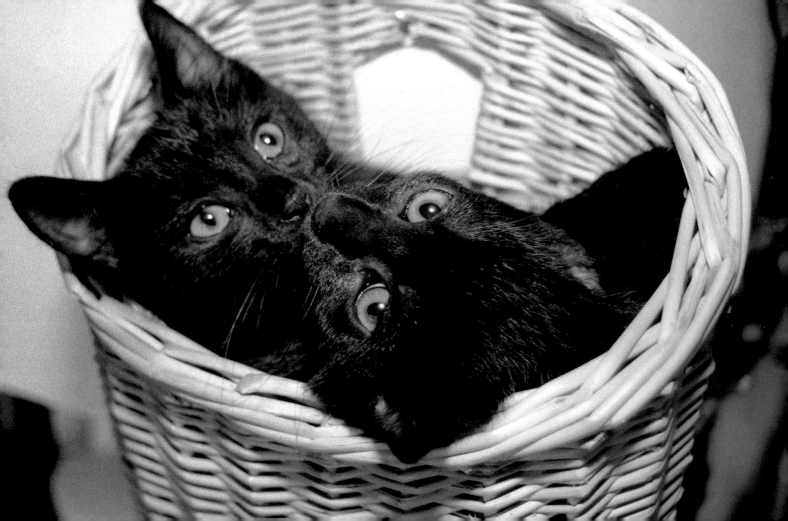

Know when to give your
unconditional indifference.

FAT TONY

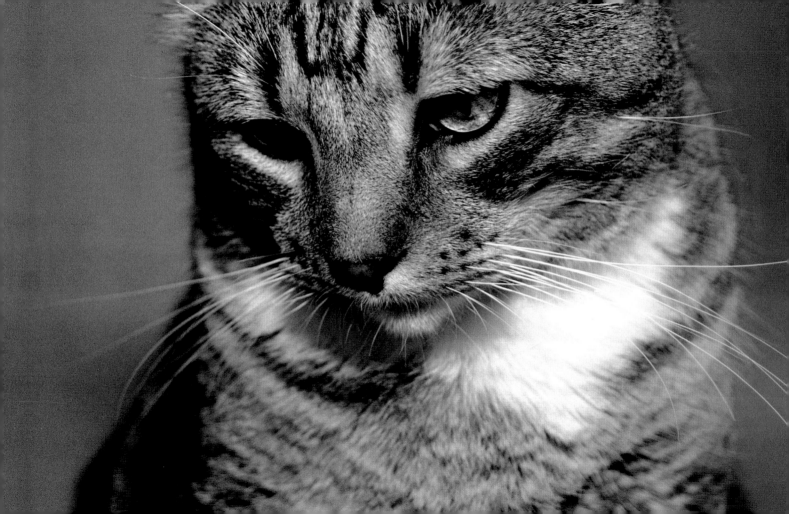

Find someone who makes your parents nervous.

OZZIE AND WILBUR

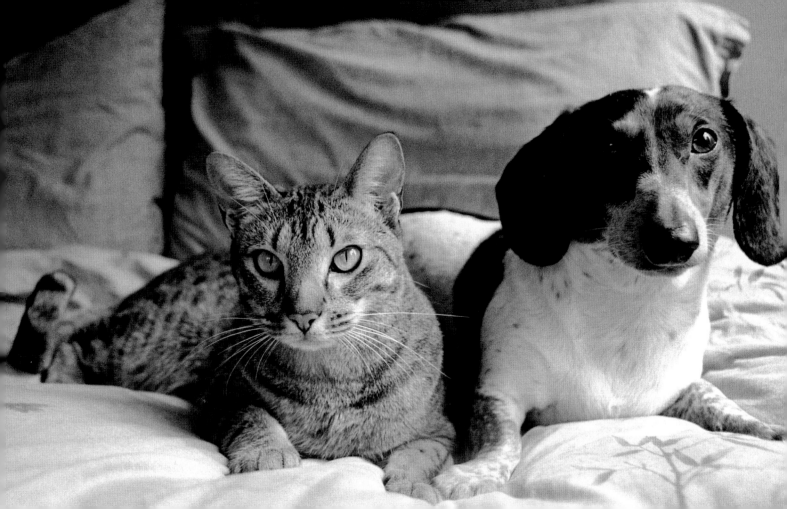

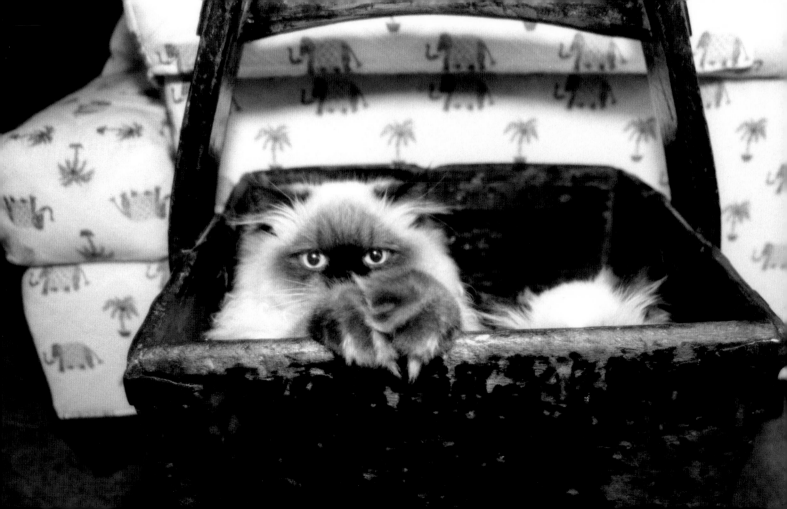

Stay totally **devoted** to your **alibi.**

SEBASTIAN

Consider your hearing loss a gain.

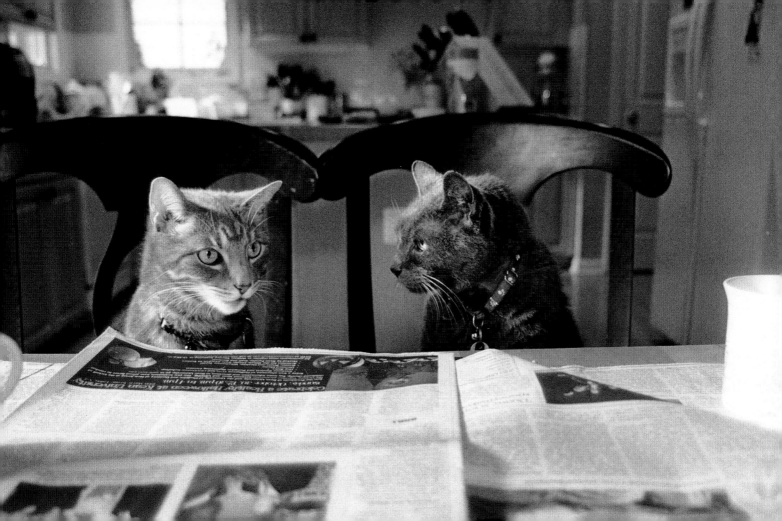

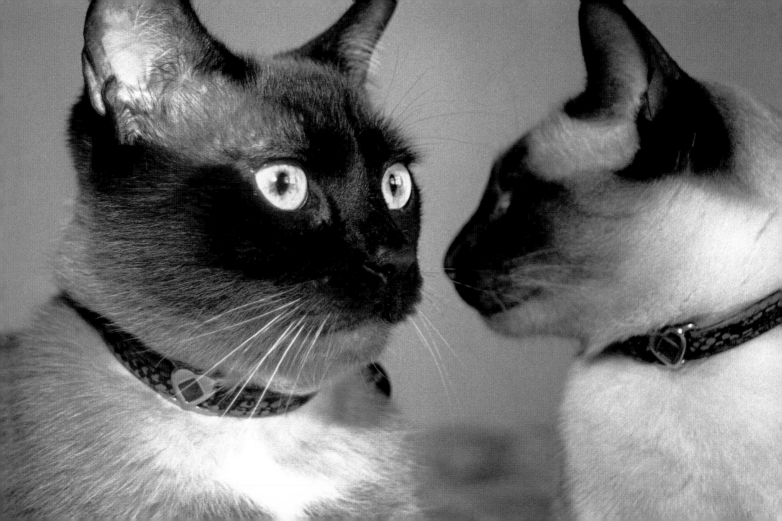

Hide your **ability** to **multitask** when you listen.

Devise a holiday evacuation plan.

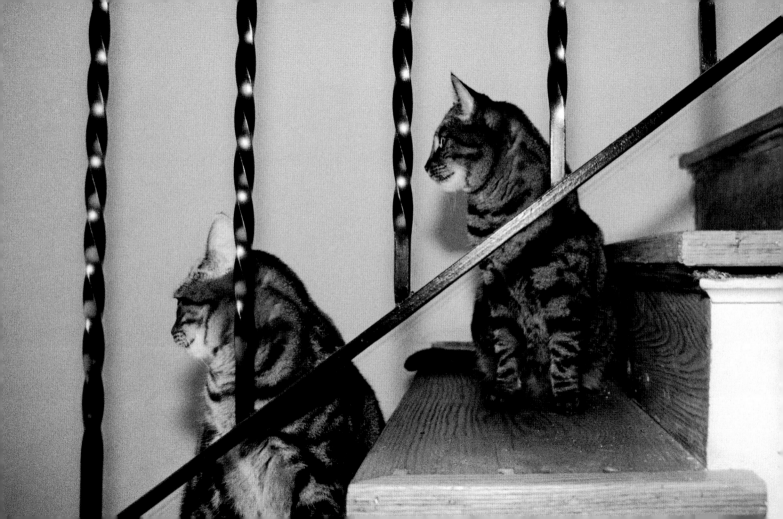

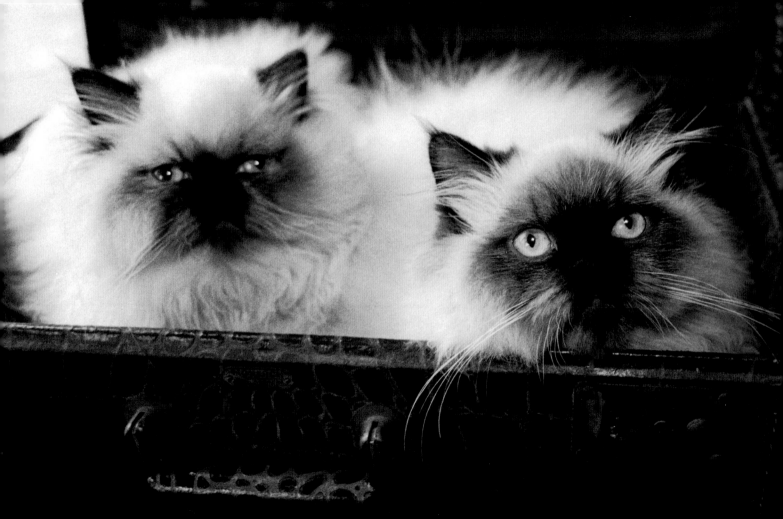

Don't just share. Time-share.

SERAFINA AND SEBASTIAN

Teach them how to give you multiple everything.

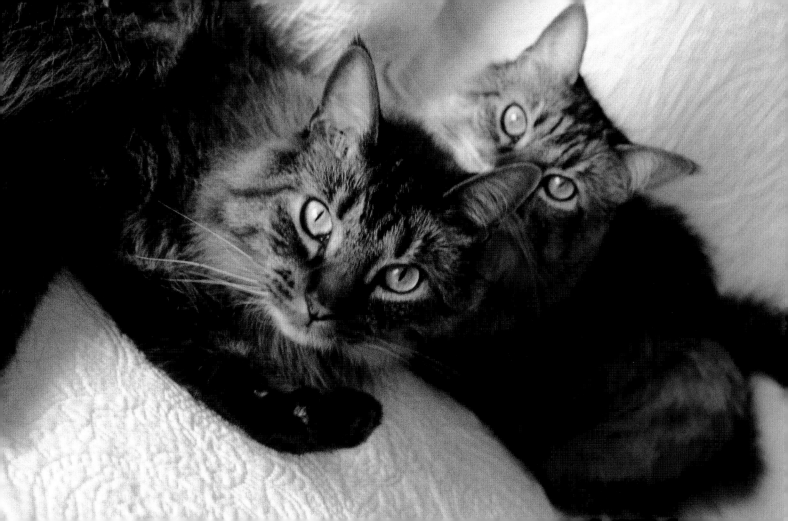

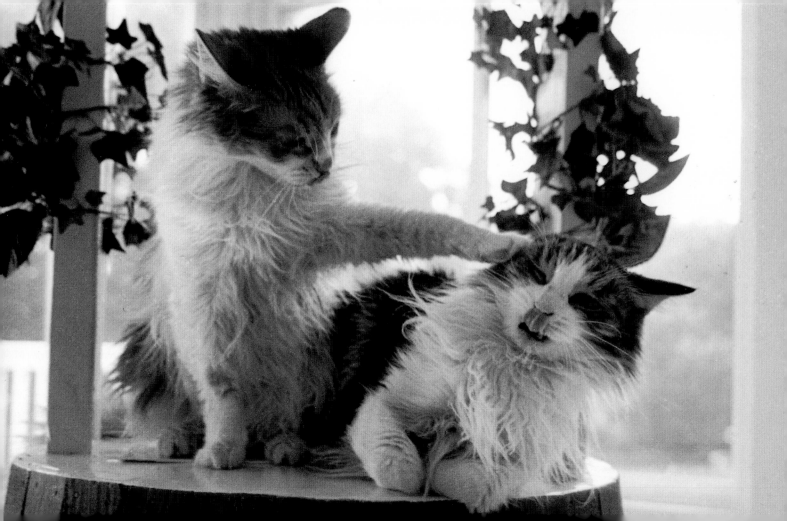

Invent your own version of couples' therapy.

Feng shui them right out of your space.

PICASSO

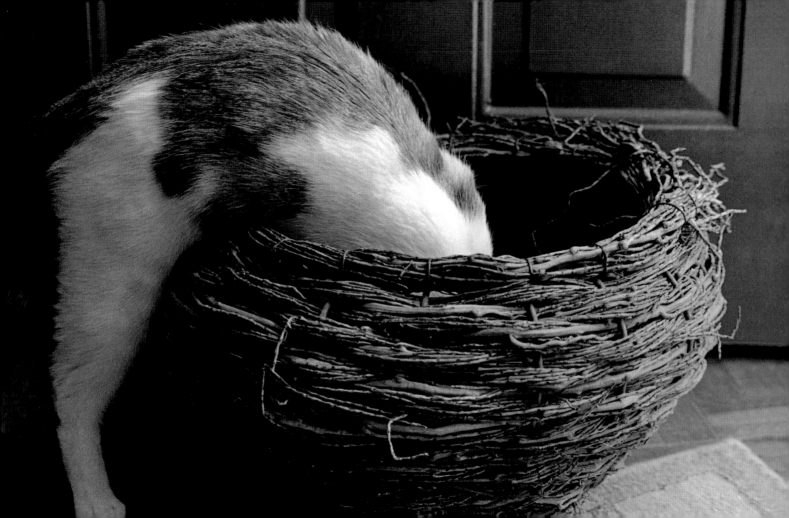

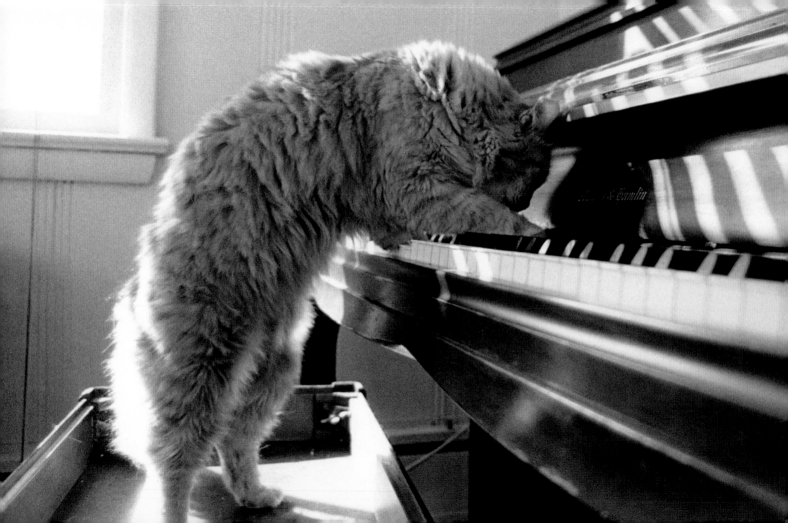

Kill monotony with showtunes.

BUCKWHEAT

Realize love can be tested in the bathroom.

ZOE AND GRACIE

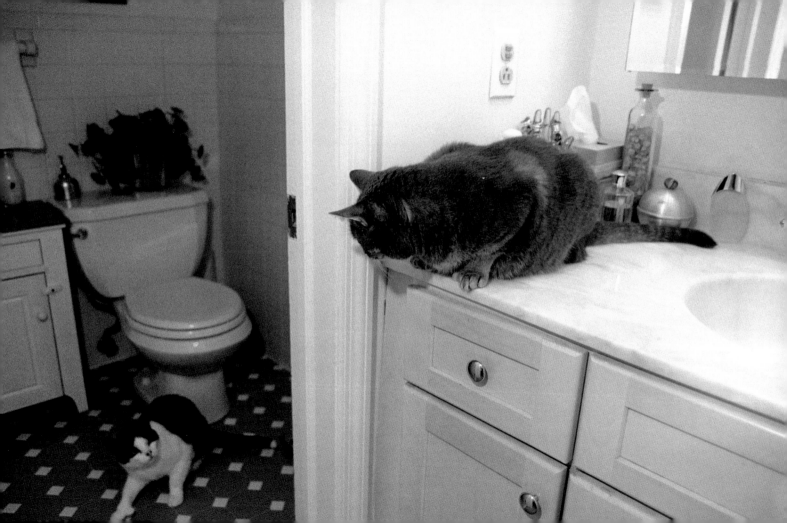

Practice random
acts of mischief.

EMILY AND STEINWAY

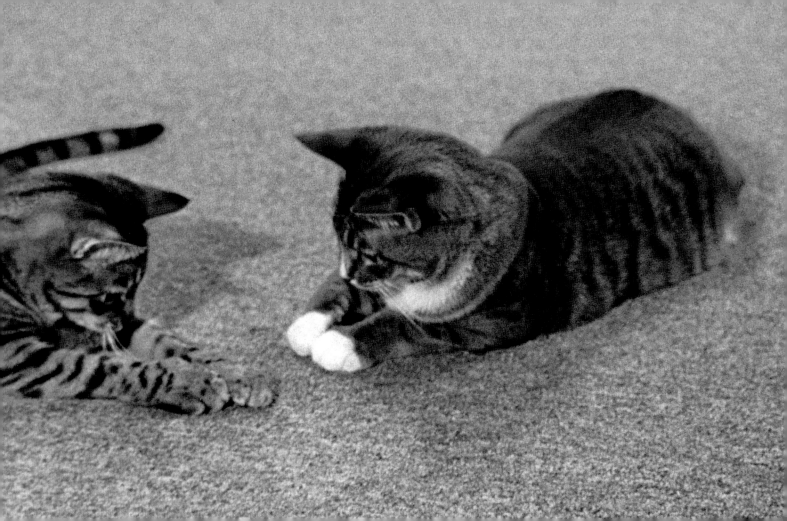

Don't be afraid to **play** the **hormonal** card.

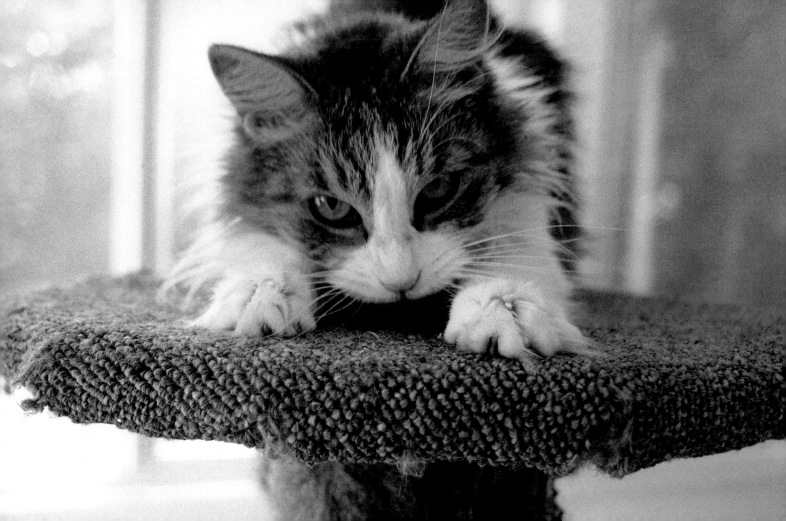

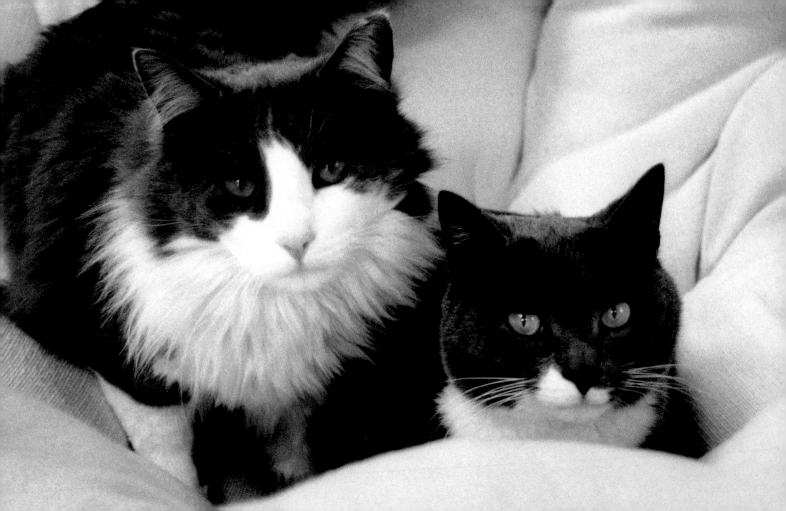

Forget Mr. Right. Find Mr. Arm Candy.

KRAMER AND SAM

If you lose at **arguing**, win at **bickering**.

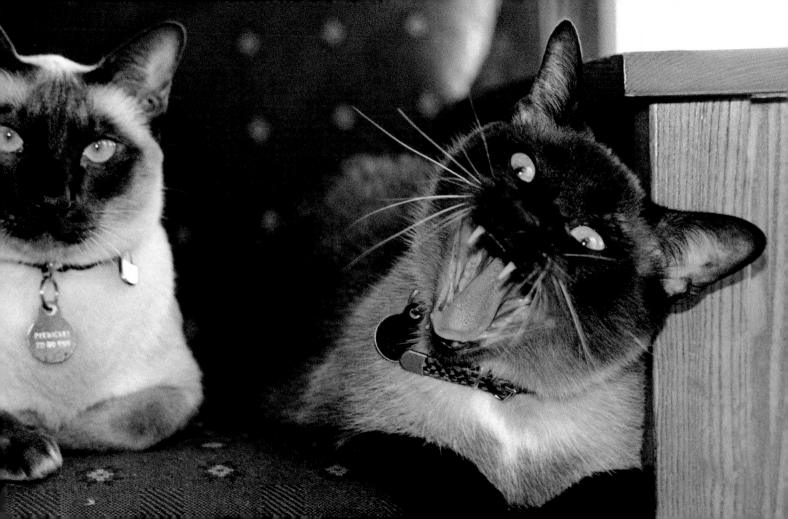

Appear domestically clueless.

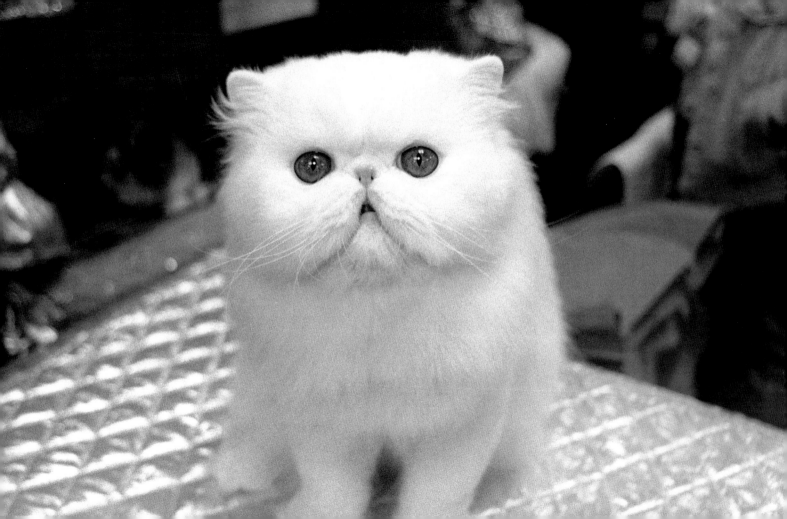

Hide the **videotape**.

ELIZA AND JEREMY

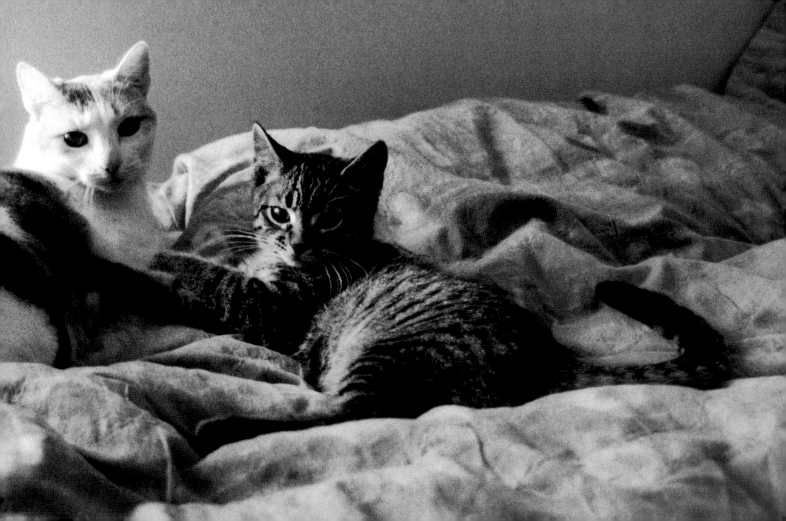

Use your nose as a lie detector.

SIMON AND SIDNEY

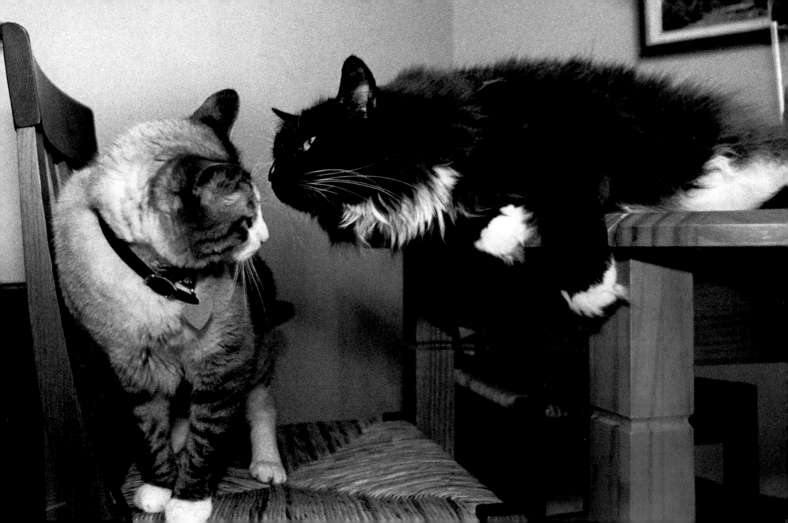

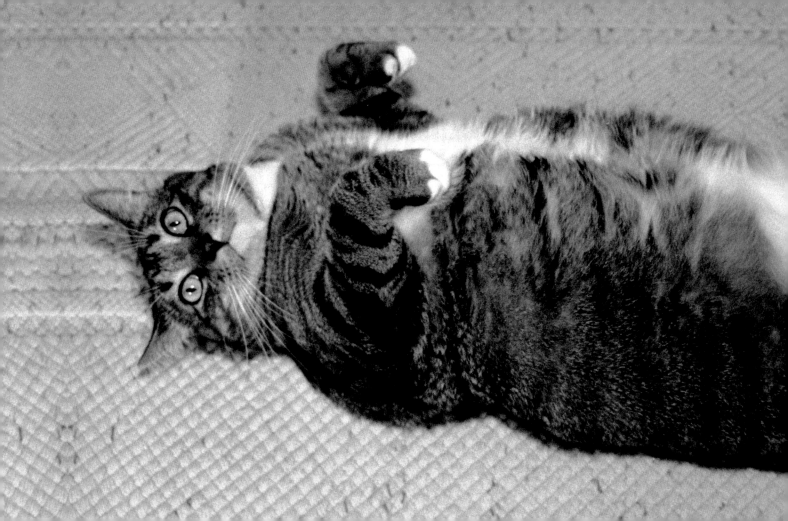

Demand the
bank account
be proportionate
to the beer gut.

FAT TONY

Synchronize your good mood swings.

Strive to be the **alpha couple.**

SERAFINA AND SEBASTIAN

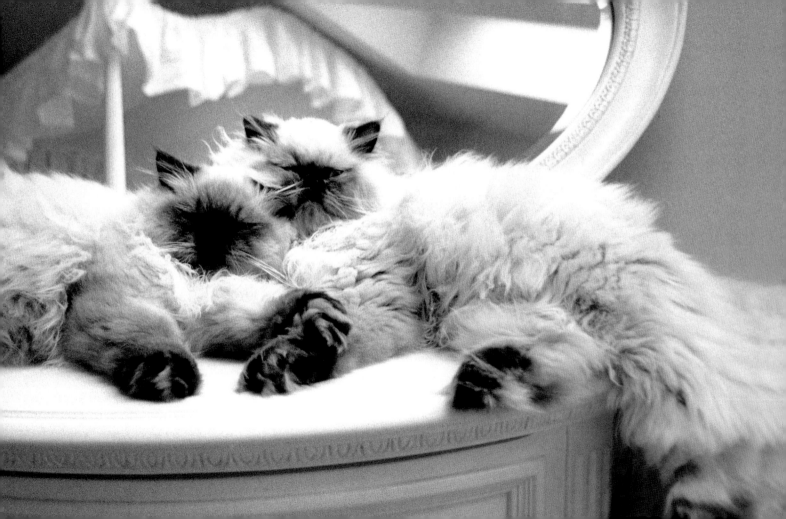

Think of **yourself** as a home improvement.

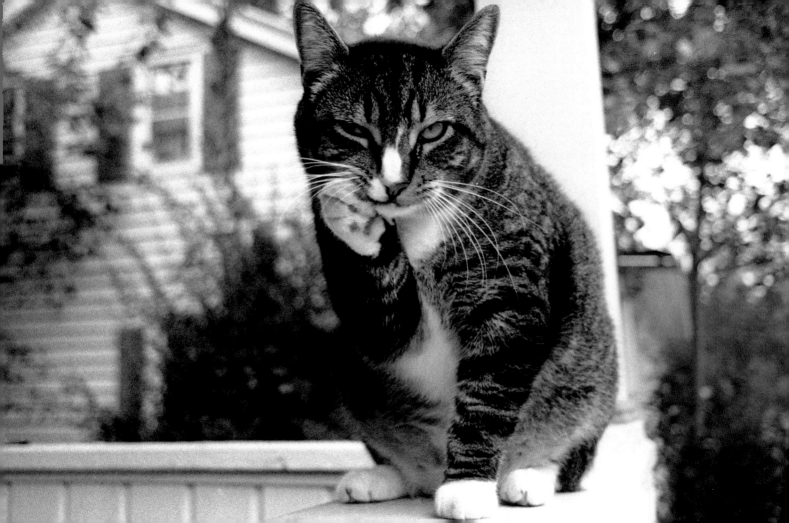

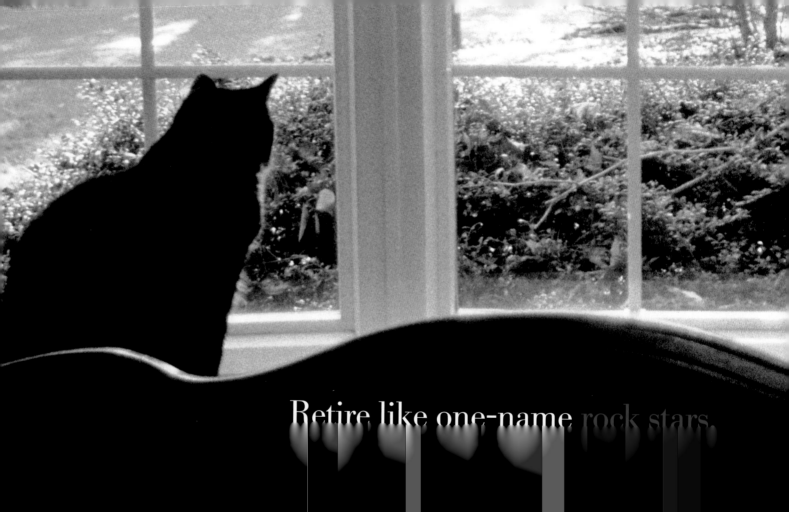

Retire like one-name rock stars.

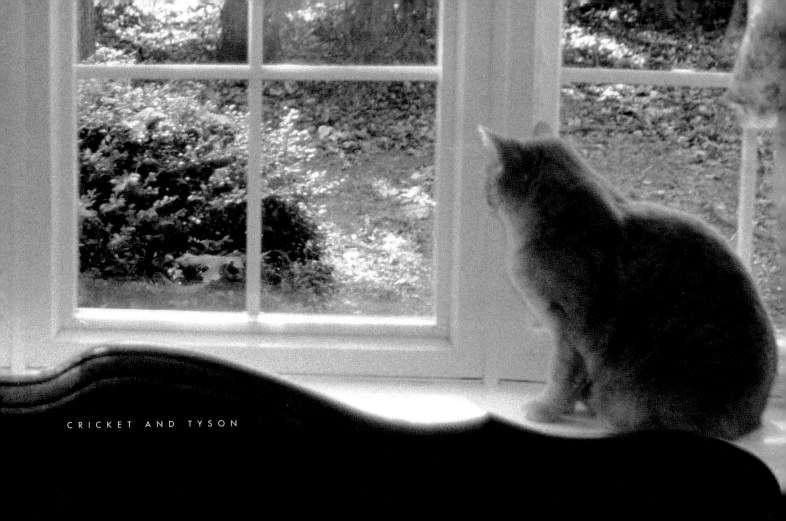

CRICKET AND TYSON

ACKNOWLEDGMENTS

Double air kissses to Marisa, Dervla, and the crew at STC. To Jim Hutchison for making the prints pretty. To all the cat owners who knew they had a star. And to our parents, Jack, Bev, Shirl, and Mitch, for all the accidental material.

PICASSO

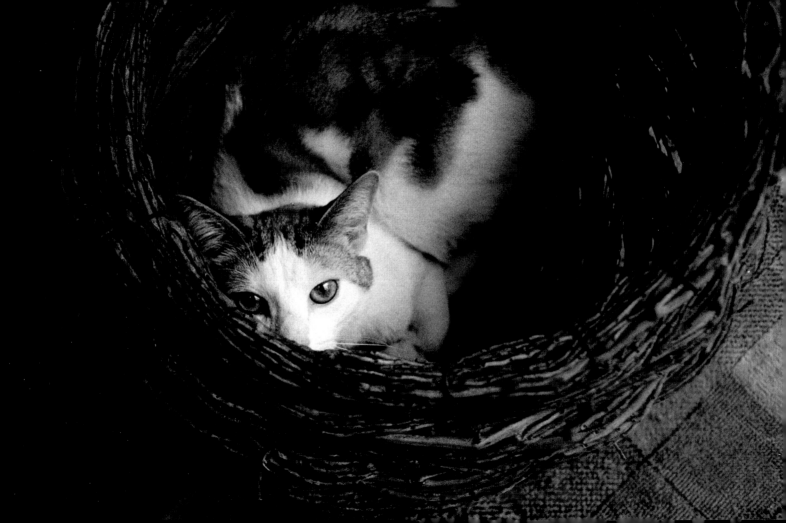

ABOUT THE AUTHORS

By day, CHRISTINE MONTAQUILA works in advertising as a creative director. She lives in Chicago with her husband Brad, son Luca, daughter Francesca, and gray tiger cat Maddie.

KIM LEVIN is a photographer who specializes in pet portraiture. Her company, Bark & Smile® Pet Portraits, combines her passion for photography and her love of animals. Kim has published fourteen books including *Cattitude*, *Why We Love Dogs*, *Why We Love Cats*, *Growing Up*, *Dogma*, and *Hound for the Holidays*.

A passionate advocate of animal adoption, Kim has been donating her photography services for many years. Kim lives in Little Silver, New Jersey, with her husband John, her son Ian, daughter Rachael, and Charlie, their adopted border collie/greyhound mix. Visit Kim's photography at www.barkandsmile.com.

Kim and Christine have been best friends since the 7th grade.